W KILL US?

MAMA! WHY DID YOU KILL US?

By

Domenico Mondrone

Translated from the Italian original's
Third Edition by
Dino Soria

TAN BOOKS AND PUBLISHERS, INC.
Rockford, Illinois 61105

Imprimi potest: V. Rev. James L. Connor, S.J.
Provincial
Maryland Province

Nihil obstat: V. Rev. Msgr. Carroll E. Satterfield
Censor librorum

Imprimatur: ✠ Lawrence Cardinal Shehan
Archbishop of Baltimore
June 26, 1970

Retypeset and republished in 1998 by TAN Books and Publishers, Inc. by permission of The Reparation Society of the Immaculate Heart of Mary, Inc., The Fatima House, 8006 Caliburn Court, Pasadena, Maryland 21122.

ISBN 0-89555-616-2

Library of Congress Catalog Card No.: 67-62523

Printed and bound in the United States of America.

TAN BOOKS AND PUBLISHERS, INC.
P.O. Box 424
Rockford, Illinois 61105
1998

Dedicated to

THE IMMACULATE
HEART OF MARY

May she, who once fled from Palestine to save the Infant Jesus from the swords of Herod's henchmen, preserve her dear daughters—who today, together with the entire human race, have been formally consecrated to her Immaculate Heart—from having their own offspring slain through abortion by the unconscious emissaries of Satan—the Archmurderer and Father of Lies. (Cf. *John* 8:44).

Truth?
Telepathy?
Hallucination?
Psychic reaction from remorse?
One of the many avenues of Divine Grace?
Perhaps a little of each.
At all events, what we are about to narrate
 touches on a present and agonizing problem.

<div align="right">

D. M.

</div>

Exactly ten years later, the time set by the person who entrusted me with her last will, I undertake to fulfill an obligation with the same trepidation with which I accepted it one icy evening in December, 1945.

For obvious reasons, due to the delicacy of the matter, I am forced to withhold the exact location and any hint that might identify the people involved in the events narrated.

D. M.

Rome, 1955

MAMA!
WHY DID YOU
KILL US?

DECEMBER, 1945

Returning earlier than usual from a short walk, I received a phone call from someone who would not give his name. To identify himself, the caller mentioned meeting me some years before.

"Mother is critically ill," he said. "Someone spoke to her about you. She says she would appreciate it very much if you could come to see her."

I couldn't figure out the reason for the caution and secrecy, but twenty minutes later I was at the bedside of the sick woman.

She made a dreadful impression on me. She was very pale and worn. Her eyes were large, still charming but heavy with suffering. She wore a white woolen cap on her head. Her movements were slow and tired. She greeted me in a low but grateful voice. Then the family withdrew and I was left alone with her.

"Father, do you recognize me?"

"Of course. Why do you ask?"

"I think I have changed a great deal."

"Not as much as you think, so as to be unrecognizable. Now tell me, what's on your mind? I am here to help you."

"Can you give me all the time I need?"

"My one wish is to help you in any way I can."

"I know, but you are a priest and have a schedule."

"My schedule is the least of my worries."

"Thank you, Father. As you see, I am approaching the end. I would like to go to Confession."

"I shall be glad to hear you. Don't tire yourself, however. I'll do my best to help you."

I drew closer, murmured a brief prayer from the *Ritual,* made the Sign of the Cross over her and listened attentively. Her mind was perfectly clear and orderly . . .

After a short time she paused. "Father, may I interrupt for a moment?"

"Surely. Do you need something?"

She nodded and touched a small pear-shaped electric bell close to her hand. A nun who was a nurse came immediately with a hypodermic needle prepared for a necessary injection.

I waited for a few minutes in an adjoining sitting room and then returned. My task would soon be completed.

After the Confession the patient asked: "And now, what else should be done?"

"I am glad you ask. I would suggest that you be anointed and receive Holy Viaticum tomorrow. If you prefer your Pastor for this, I can stop and see him on my way home."

"No, I would rather have you. But why should

we wait until tomorrow morning? Couldn't it be done this evening?"

"Certainly."

Again she touched the bell, and this time, with the Sister came a young woman carrying a baby girl. Then her husband and a boy of five or six entered the room.

"Sister, I have told Father to do everything this evening. What do you say; and what do you all say?"

The daughter and her husband looked at each other. Their eyes filled with tears and they could not speak. But the Sister spoke up: "I think this is God's inspiration. Do so by all means. Besides, it will help you to have a quiet night."

"So, Father, I am in your hands."

I went to the nearby church which the pastor was preparing to close for the night. There I procured a surplice, a two-sided stole, the holy oils, holy water, a Ritual and a burse with the Blessed Sacrament. Again I put on my overcoat and in a few minutes I was back at the bedside.

Meanwhile the Sister had converted the chest near the bed into a little altar, neat and devotional, and even with flowers, which looked to me like a miracle of beauty.

Before receiving the Last Sacraments, the sick woman expressed a desire to speak to me again in private. When all had withdrawn, from a small plastic bag she drew a stiff, bulky envelope, handed it to me and said:

"This is the last favor I am asking of you. Will you promise me to do what I am going to ask you?"

"What is it?"

"My last wishes are here."

"But we are not supposed to be executors of wills."

"It is not that," she assured me with a slight smile. "It is the story of my wretched life, from the time I was a bride up to the present. I want you to publish it ten years from now. Only be as careful as possible that no one may recognize the people mentioned in it."

"Did you write it?"

"Of course."

"Someone may recognize your style."

"Then make it unrecognizable."

"How?"

"Re-write it yourself. Perhaps I am asking too much; but it will be a work of charity. Will you promise me? I have great confidence in you."

She could see the strange hesitation on my face.

"I assure you," she continued, "there is nothing compromising. I have been thinking of doing this for years; and the more I thought of it, the more peaceful I felt. Please don't say no. You may read it tonight if you wish. And let me repeat: there is nothing compromising in it for anyone. It is something seen in the light of God, after passing

through experiences and expiations which I wouldn't wish on any mother. It is something that has shortened my life. I wouldn't want the like to befall any other mother."

"Well, I'll do my best."

"Thank you!"

A slight touch of the bell brought everyone back except the two children, who had meanwhile been put to bed by their mother.

The Last Rites were administered in an atmosphere of perfect peace and serenity.

It was nearly eight o'clock. A furtive glance at my watch made the sick woman realize that I wished to leave.

"You may go, Father. I have no words sufficient to thank you. I won't keep you any longer; I feel that I am at peace with God."

"You may be sure of that," I said as I arose. "Now I'll give you my blessing and wish you good night. Should you need me tomorrow morning, don't hesitate to have me called."

"Tomorrow morning? Shall I be able to see you . . .?" She took my hands, held them for a moment in her fevered grasp with her eyes fixed on me in wordless gratitude, kissed them and let them go with an expressive nod of good-bye.

Down in the street, I stood at the car-stop waiting for the streetcar and thanking God for having made me a priest, a link between Him and souls.

The streetcar was already coming when the

janitress rushed out to me. "Father, the people upstairs want you in a hurry; they beg you to come back."

As soon as I arrived in the hall of the apartment, I saw that everything had changed. The sick woman was screaming like a maniac. The children in the next room had been awakened and were crying with terror. Their mother was trying to quiet them, but she herself was weeping and seemed inconsolable. The Sister and the sick woman's son-in-law were doing their best to hold her in bed. She was struggling and crying to get up, for she was burning in a dreadful way.

My appearance did not calm her; on the contrary, it made her more furious. Those eyes which shortly before had been so kind and peaceful were now fixed on me with some kind of inexplicable hate.

"There he is. He has been talking to me about mercy. What a liar! He told me not to think of my past; and now he does not see that my past is coming to meet me. They are there; they look at me one by one. They look at me with hatred. Nobody sees them; but I do. I do see those faces, those eyes, those looks as cold and hard as always. On a night as dark as Hell they knocked at the door of my house. I rushed to open it, but as soon as I saw them I shut the door and wouldn't let them in. I know the way they were looking at me . . . !"

"Calm yourself, Madam. You have done everything to merit the good Lord's mercy. Be at peace. Trust my word as a priest. Come, make just one act of trust and commit yourself to Him."

Saying this, I sprinkled the bed and the room with holy water and started to sit down by the poor sick woman.

"Oh, what have you done? Did you think they were devils? They are not devils; they are not at all afraid of your water. They are standing over there, steady, mocking and as stern as ever."

"The hallucinations she used to have," her son-in-law whispered to me; but the sick woman heard him.

"You are the one who has hallucinations! This is no hallucination; they never were hallucinations—but you could never understand. Oh, my!"

At this she collapsed. Her pulse seemed to stop and she remained for some time motionless, her eyes staring at the opposite wall. She seemed without senses or mind except for her eyes, which were bright and wide open as she gazed in that direction.

I took my *Ritual* and began to pray. Then something no one could have foreseen happened. With a sudden movement she snatched the small book from my hands and threw it on the floor.

"What's the use? All this won't help. Don't you see that there is nothing more that you can do? Don't you see that I've already been damned?"

She turned to the other side. But immediately afterwards she turned back towards me as if compelled by some vision which had filled her with horror.

At length she stared at me without recognition. Then it seemed as if her lips assumed an expression of contempt, or perhaps of scorn. She instinctively grabbed my arm like a drowning person trying to clutch something to keep afloat. She remained like that, staring absently.

I didn't know what to think.

The son-in-law and Sister were on the other side of the bed; he was holding the wrist of the sick woman's free hand while the Sister, rosary in hand, was praying.

I was watching her carefully, my eyes were on hers as life seemed to reappear in them. I leaned forward and said: "My Jesus, mercy!"

She seemed to understand. Her eyes first wandered uncertainly towards the ceiling as if following—who knows?—some thread of her memory. Then somewhat mechanically, with neither understanding nor feeling, she repeated: "My Jesus, mercy!" "My Mother, my trust."

Encouraged, I pronounced once more the most holy invocation to Jesus, and she echoed it after me automatically as before.

"Perhaps she is in a coma," whispered her son-in-law to the Sister.

The Sister handed me the crucifix of her rosary,

which I put to the woman's lips. At its touch she was slightly startled. A movement of her head gave me the impression that she was refusing it, and I trembled with fear.

"It is Jesus, who wants to save you. Kiss it!" I said, and I kissed it myself to show her how to do it.

As I did so the dying woman opened her eyes wide. She extended her lips towards the holy symbol of our Saviour as if to kiss it with evident fervor. But suddenly she compressed her lips again and I couldn't understand whether the gesture was that of a kiss or an expression of contempt. She remained motionless.

Then with a scarcely perceptible voice she seemed to murmur: "Pray . . . have faith . . . leave it . . ." Again her lips contracted.

Once more I brought the crucifix to her lips. The reaction was a sob.

A few moments later when I saw her son-in-law drop her lifeless wrist, fall to his knees and weep, burying his face in the side of the bed, I realized that she was dead.

What took place when his wife came in is easy to imagine. I saw how much they had loved her.

But I was thinking of something else.

"My God, what did that last gesture mean? Was it a kiss or a refusal?" That question kept coming to my mind all the way home like the rhythm of a pendulum. I had to walk, for at that late hour

there was no public transportation.

The next morning at the "Memento" of the dead in Holy Mass, I felt as if a sudden voice had spoken to me—not in my ear but in the very depths of my soul, which was still severely shaken—*"Modicae fidei, quare dubitasti?"* (O you of little faith, why did you doubt?).

This seemed to me a sign of such certainty that it would have been rash to ignore it.

* * *

A few days later I held the mysterious envelope in my hands: "Should I open it, or not?" I thought it over.

"It is a will," I said to myself, "that I must make public only after ten years. Why open it now?"

I was about to hide it in the bottom of a drawer when the question came: "What if I should die before that?" And so I took a larger envelope in which to enclose the sealed one and wrote across it: "This is the will of a person at whose death I assisted. This person wants it to be made known exactly ten years after her death. It is to be opened and publicized in December, 1955. Please carry this out with scrupulous exactitude and conceal the name of the person."

DECEMBER, 1955

Today I began to carry out that poor woman's request.

This morning, before proceeding to open the letter, I wished to celebrate the Holy Sacrifice of the Mass for her. "O you of little faith, why did you doubt?" came back to my mind once more and brought back to me that same sense of peace which it had given to me at that time.

I slit the envelope and drew out twelve hand-written sheets. The handwriting was small, thick and regular, manifesting perfect self-control. The pages must have been written at one time without interruption, because only towards the end very slight traces of weariness could be seen.

Here was the work of a brave and determined hand which was aware that it was tearing down a screen behind which were things which she was eager to make known. "I wouldn't want the same thing to happen to any mother."

Where the location was generally indicated, there were dots. The date was that of January, 1945. The letter was addressed: "To all mothers." It was signed: "A mother."

Here is the text of the "letter," since I saw that I should regard it as such. I immediately typed it and destroyed the original, since this also was another detail which had been suggested to me.

I was careful to alter several secondary circumstances so as to destroy any clue to the author's identity.

JUNE, 1914

A few weeks before the outbreak of the first World War, I married a man whom I had known since childhood. Our families lived in the same apartment house and were united by a long-standing friendship. As we grew up, we used to spend our vacations together, either at the beach or in the mountains.

As I became older, I realized that the only difference between the two families was that his was very religious, while mine wasn't. But this did not cast a shadow on the friendliness of our relationship, because the respect we had for each other united us in everything.

I remember once on my father's birthday, which happened to fall on a Friday, that my mother served fish to us all because some of the other family had been invited to dinner.

I am stressing this difference because, unfortunately, it was going to affect the lives of the children of each family; three in mine and eight in his. Anyone of discernment who came into our living rooms could recognize us by the paintings on the wall and the newspapers and magazines

lying around. Theirs were all, or nearly all, religious (as I used to say, "pious like you"), while ours were all worldly.

* * *

One August evening when we were in the mountains, I suddenly fell ill with deadly abdominal pains. I was bathed in a cold sweat and everyone was alarmed.

It was already dark, and a heavy storm was brewing which was likely to last through the night. The nearest doctor was over three miles away. Between his place and ours there was no telephone or other means of communication. As soon as my family decided to send for him, the one who offered to go and who would not hear of letting anybody else do it, was the man who later became my husband.

A few minutes after he left, the storm broke with dreadful violence. I can still see the lightning flashes of that night and hear the crash of thunder which seemed about to destroy the world.

I recall on that occasion that my friend's mother began to recite the Rosary aloud and that all joined in and prayed together as they had never prayed before and as I have never heard them pray since.

My condition was getting steadily worse. They were not sure that the doctor would be found at

home and whether he could be persuaded to come in such a storm. One, two and three hours went by, yet no one appeared. At one time I felt that my end had come.

Then my dad, who had been almost all that time watching at the window, said that he heard a whistle in the distance and saw in the darkness a waving flashlight in answer to his signals.

When the physician arrived I was almost completely unconscious and I could not realize what he said or what he did to me. All I know is that at dawn I woke up, the pain had disappeared and the doctor was smiling down at me in a paternal manner.

"Cheer up," he said, "it's all over. Tomorrow you'll be up and around. Aren't you glad?"

To my words of thanks he answered quickly: "Don't thank me; thank him. He is the one who saved you. Had he arrived just a little later . . . !"

Behind the doctor stood the young friend of the family, his eyes sparkling. All at once I instinctively opened my arms to him to hug him like a brother and to kiss him.

Such was the budding of a love which perhaps was already there, though concealed. That episode made it suddenly blossom and led to our marriage.

* * *

During the first two years our life together was
full of happiness, which reached its peak when a
baby girl came to join us. But this joy almost cost
me my life because of the many hardships and
acute pains which I suffered in giving birth to this
child. It was a miracle that my daughter and I
lived.

Right after that event, my husband was drafted;
but due to his assignment we were able to see
each other at least every two months, sometimes
even oftener, throughout the whole war.

One day my husband and I came to talk openly
about children. "There is no limiting Divine Prov-
idence, my dear!" He said this with the firmness
he used to show in all his decisions. I immedi-
ately understood that to go against him could have
opened a gap between us which might have
widened into an abyss, so I preferred to remain
silent. But inside me a rebellion was kindled
which could never be put down: "Am I to play the
brooding hen at home? Oh, no—not I!"

By talking to a girl friend I had started to see
often since my marriage (she lived in the same
building above us on the second floor), reading
the stuff she continuously fed me and remember-
ing, besides, all I had suffered when my first child
was born—I was becoming extremely frightened

at the thought of having another.

Moreover I must confess with deep regret that my love for parties had a great deal to do with this repugnance for pregnancy. Besides, I had a strange obsession for keeping my figure, so that I would rather die than have it "ruined," as my faithful girl friend would say.

Apart from my grave sins, may God forgive me for the hours I spent alone before a large mirror in our bedroom in silly self-admiration.

"Why do you read this rot?" my husband asked me one day after a glance at certain magazines.

"Don't you like it?"

He did not answer for a moment, then he suddenly asked: "Do you know that saying?"

"What saying?"

"Tell me what you read and I'll tell you what you are."

"Really?"

That was all at the time, but from then on my husband did not find in our living room such reasons for criticism. Like a convent school girl, I was reading in secret.

With tears of vexation I told my daily companion of my husband's decision about having children.

"You are foolish if you listen to him."

"But what can I do?"

"Are you still so naive?" And from that day on she became a skilled teacher of contraceptive

practices which I began to follow with a docility which she termed admirable.

* * *

Despite all precautions, about two years after my first pregnancy a second one occurred. After an attack of typhoid fever which had nearly killed him, my husband had been given a two-month convalescent leave.

I told the news to my girl friend. "Be careful," she said, "and wait for your husband to leave."

I waited, but I longed for my husband to go. How my selfishness was causing me to lose, little by little, my love for him.

I can still remember the joy he expressed as he kissed me good-bye, his happiness at the thought of the little one who would soon come to increase our family.

"Take good care of it, my love. It is the most precious trust I leave you. Good-bye, darling."

As soon as he left, my girl friend and I began looking for a way to get rid of that "dear trust."

"Be careful and patient," she kept saying. But I couldn't be patient and gave her reason to fear that I would not even be careful, so deeply was I possessed by the desire to make haste.

Chance came to my assistance. One evening while we were together, we happened to hear some shots under our window. The whole neigh-

borhood was greatly disturbed. I turned pale with fright and threw myself on the bed.

"Now is the time!" she said.

I shall not relate to what we resorted to free me. In less than a week all had been straightened out.

The letter that my husband wrote me, after I had told him what had happened, made me shed tears of emotion and remorse. I had been able to display such sorrow, that nearly all that he wrote was to console me. My girl friend sneered. But confronted by that letter I truly felt like a detestable monster.

* * *

When my husband saw me a few days later, he showed a new affection for me.

"Don't worry, dear. It was bad luck. But you are healthy and Our Lord won't fail to console us."

* * *

Eight months after that abortion, I felt the signs of my third pregnancy. My girl friend advised me to make haste: "The sooner you get rid of it, the better."

But I was strangely uncertain. It was a struggle between my love for my husband and the dread

of the burden I felt growing within me of which I wanted to be rid.

I wavered for several weeks and the weeks became two or three months, as far as I can remember. Finally one morning I rushed resolutely to see my girl friend and asked her what to do.

"At such an advanced stage, it's no joke!"

I stared at her in dismay.

"Now we need an expert. I know of a very skillful nurse who could handle it; but she'd want a lot of money.

"How much would she want?"

"Between one and two thousand lire. Sometimes, even three thousand. She is terribly afraid of getting involved, and, she says, one must be paid well to make it worth the risk."

"Can you guarantee her ability?"

"Oh, I know her well. You don't have to worry about that."

"I'll let you know by tomorrow morning at the latest."

I left undecided; but as soon as I was back in my room, I grabbed the phone: "O.K.! I'll be ready tomorrow morning!"

The nurse was there on the dot.

I showed some hesitation about submitting to her "treatments."

"Can you tell me, Miss, what to say to my husband by way of explanation?"

"Why, doesn't he agree to this?"

"Not on your life!"

"I'm sorry. You'd better think of something yourself. I don't want to get involved in a mess." And she pretended to be about to leave.

"Are you going to abandon me?" I realized that it was a ruse so as to squeeze three thousand lire out of me. I had to do a lot of lying to get the money that same day.

To avoid any clue that might compromise her, she told me to go to her home alone. I went. On my way back I started hiccupping as I had never done before and I was greatly upset. About midnight I felt sick and had barely strength to get to the phone. "If there is any noteworthy development, give me a ring," she had said to me coldly, so as not to arouse my suspicions. The telephone kept ringing, but there was no answer. I found out next day that she had indeed been called elsewhere.

I was in a state of terror. I wished I had my girl friend with me, but just that morning she had gone out of town and would not be back for the next few days.

More and more distressed by the hiccups and pains, I decided to call my husband's cousin who had recently started to practice gynecology. He questioned me insistently and wanted to know the cause of my hiccups. I was firm in answering that I knew nothing about it—that it all just happened.

The doctor gave me a skeptical look which made me bitterly regret having called him. A few hours later he was to attend to my second abortion with the help of a nurse, a big woman who had been supplied by the doctor's hospital.

I got out of it better than I had feared. What made me freeze and kept me anxious for some days was what the nurse whispered to me before leaving, after the last of the three visits she made during my convalescence.

"Think it over next time, before you do such a foolish thing."

I protested and even used rude words. But she must have had a lot of experience.

"I spoke for your good, Madam. Remember, this may cost you your life, as it did the infant's. And there's also a jail sentence."

With this, she left.

* * *

Two days later my husband came home on a short leave. I saw that he was worn out. His cousin had notified him immediately as to what had happened, but had acted as a perfect gentleman. His professional secrecy made him as silent as a confessor.

I was quite worried about the nurse—"that damned woman!" as I called her. But I felt reassured when I learned that she was a very prudent

nun. "If she is a Sister," I thought, "she will not start a row between me and my husband."

After this new episode my husband insisted that two or three famous gynecologists visit me. They all found my health perfect.

This did not overcome my stubborn will, which was guided by my shrewd mind and which had at its disposal ever new resources.

I shall refrain from narrating the details of the five more abortions of which I was guilty during the following years. This story is extremely disgusting to me, and besides, it would be scandalous to tell. However, what is almost beyond explanation is the way that chance seemed to help me.

Up to the next to the last abortion, my husband never suspected the truth, since every time I was able to simulate my sorrow so well. A few days after the sixth time he suddenly said to me:

"If I were certain that you were in some way to blame for this, it would be the end of you."

"What would you do?"

"I don't know . . . I might be the murderer of my wife as she was of my children!"

"How dare you dream of such a thing!"

He made no answer, and I do not believe that in my whole life I was ever a better actress. I suddenly and desperately burst into tears and forced my husband to retract what he had said.

The occasion of my last abortion seemed

almost to throw the blame on my husband.

He was driving a new car for the first time and invited my daughter and me to take a ride. At a bend in the road we had a collision. Fortunately it was less serious than it could have been. The only damage was some scratches on the fenders and the sudden fright. That gave me my chance to kill my seventh child a few days later.

* * *

Some weeks afterwards, due to an infamous denunciation to the local Fascist board, my husband was taken in for questioning and swiftly sent to confinement. I was left alone with my daughter, by then a girl in high school. She was attending a religious academy. Living with us was an old housekeeper who had been with my husband's family and who was kept in our home out of charity. Due to some mistake made in her youth, she was unable to return to her own family in the South.

One afternoon, when I went to the school for my daughter, the Sister Portress gave me an invitation to a lecture "for ladies only" which was to be held in their school hall.

I attended.

I knew the woman lecturer by name. Her topic was on the question of having children. From the beginning I assumed an attitude of perfect indif-

ference, as though the matter did not concern me at all. Towards the end the lecturer, enumerating the incalculable responsibilities of certain mothers, began to harp on the destiny of the souls of so many unborn children who had been destroyed in the same womb wherein they had been conceived.

* * *

The destiny of their souls? . . . Frankly, I had never thought of the question because I was convinced that there was no reason to consider souls, especially in respect to two or three month pregnancies as mine had been. I considered that part of the lecture as idle talk, a rhetorical device employed in very bad taste.

"Don't you think her closing remarks were nothing short of nonsense?" I inquired of the lady sitting next to me.

"You may think so, but I don't," she replied with conviction. Her words struck me as sharp and inquisitive.

"It is a strange thing . . ." I rejoined to get out of it.

"There's nothing strange about it. Think it over. Even if it were doubtful, would you run the risk of denying a soul its eternal destiny?"

"I made a mistake in coming," I said to myself, "and I should have kept my mouth shut."

As I returned home I tried to convince myself that I had listened to drivel. How can one talk about a soul in a small clot of mucilage that is just beginning to take on human shape? Meanwhile I remembered the big words used by the lecturer in describing the presumed slaughter of thousands and thousands of human beings.

*　　　*　　　*

That evening I could not eat. I read something very silly to change the course of my thoughts, and when I went to bed I decided to take a sleeping pill. This made me sleep until late the next morning. After a good sleep, the disturbing thoughts of the preceding evening had disappeared. During the following days I mentioned the matter to several girl friends and even to a doctor. I found them all in agreement with me.

As for my husband, I didn't know what to think. There was no definite news as yet. I don't know how many times I tried to communicate with him and to send him some packages of food, clothing and books. It was all useless.

One day the old housekeeper—who, as my husband used to say jokingly, "was the nun of the house," because she devoted herself with such determination to her religious life—suggested that I recommend him to St. Rita, the holy patron of the impossible.

So one evening before going to bed, I began to pray to this holy woman, using a religious booklet which had been discarded by my daughter. After that prayer I felt more confident and more peaceful. I had the conviction that what I was not able to do for my confined dear one, could be obtained by the Saint to whom I had begun to commend him.

It was a long time since I had prayed. I had stopped praying altogether after a severe reprimand which I had received from a confessor from whom I had barely obtained absolution. He granted it because I wanted to receive Holy Communion with my husband and daughter at the time she made her First Communion.

My heart seemed to open to the hope that St. Rita might listen to me. The housekeeper had assured me with the certainty of a theologian: "Pray! If you can't get this grace, she will send you a greater one. One never prays to the Saints in vain. But they do what they wish with our prayers. Leave it to them; they know better than we do." It was a doctrine I couldn't quite grasp at the time, but against which I could find no argument.

* * *

One night I had been sleeping for about two hours when I was awakened by a strange voice: "Mama!"

My daughter was spending the night at her aunt's; and besides, it wasn't my daughter's voice. Startled, I turned on the light and sat up, listening. I thought that the voice might be coming from my neighbor's apartment across the hall. But I ruled out that possibility.

I had heard that voice clearly and very close by in my room, at my side—I might say at my very ear or even within myself. I hadn't the slightest doubt that I had heard it. I could have sworn to it by what I held most dear. Moreover I noticed that I heard not just one voice, but several voices together, so well fused as to seem but one.

Now in my room I heard only my palpitating heart. I had the strange feeling that it could be something mysterious. I couldn't explain to myself why my mind spontaneously reverted to the housekeeper's words: "If you can't get this grace, she'll send you a greater one." Why should I dwell on these words?

I don't remember how long I remained thus listening as if suspended in emptiness, thinking of nothing else, incapable of relaxing. At last the thought crossed my mind that it might have been just a nightmare to which I was giving too much importance. So I resolutely turned off the light and lay down. But I knew that I couldn't go back to sleep.

After less than a quarter of an hour, the same voice as before, or rather, the same voices fused

together as one, called again:

"Mama . . .!"

Now I was quite awake, and I was certain that these voices were coming from over here in my room at no more than a few steps from me. The voices were as if muffled, smothered, with a mysteriously sad tone.

This time I neither turned on the light nor sprang up in bed. I was paralyzed. "Is this a dream or something real?" I asked myself. And in saying this I began to touch my hands, to count my fingers, to unbutton and rebutton my nightgown at the neck, to count the slats of the Venetian blinds through which the light filtered from a lamp post in the street. Then I stopped thinking. All I did was to follow my heartbeat, which I could not control. I tried to change the course of my thoughts, but I could not.

At the close of the next quarter of an hour that chorus of voices came again—clearer, more persistent and more sorrowful than before. This time my fear was about to overpower me. I overcame it with a movement of rage. "Why can't I find out what this is all about?" I turned on the light, jumped out of bed and ran to wake up the housekeeper. In reality, I was seeking protection from my fright.

"Have you been hearing anything?"

"What should I have heard?"

"I don't know; some noise, a voice, some

voices calling."

"No, Ma'am. I heard nothing; let me sleep."

"But I heard them!"

"Perhaps they were ghosts," she said, just as a silly reply so as to be left in peace. With this she turned over on her side and went back to sleep.

But it was just that very stupid reply that robbed me of any hope or chance to rest. I went back to the living room, turned up the three rows of chandelier lights and began nervously and distractedly to page through a magazine. Then I took up more magazines, one after another, without being able to read any of them.

Thus I remained until morning, when I lay on the sofa and fell fast asleep through exhaustion. I woke up when the housekeeper, coming back with the marketing, rang the bell because she had carelessly forgotten her key.

"Most Holy Virgin! You look awful! What happened to you last night? You didn't sleep and didn't let me sleep either."

"Shut up and get going, and don't be asking foolish questions!"

She went to work in the kitchen, but I heard her grumbling: "It might have been ghosts after all!" and she ended with a laugh which made me angry.

"Lucia, I told you not to be silly. One more word from you and I don't know what will happen this morning. Understand?"

"I understand that you are upset, so I shall say no more."

I spent that day visiting people, as many as I could. I even went to church—why?—I don't know. And when I found myself in front of St. Rita's statue I kept on going.

* * *

That night I went to bed very late. It was almost one a.m., as I had stayed up with the usual girl friend, but without saying a word about what had happened to me on the previous night. I might have suddenly found myself the laughing-stock of the house and of the neighborhood. I set the alarm and threw myself on the bed, longing for sleep. No sooner was I lying down than the mysterious voices came again, not only once, but two and three times:

"Mama! . . . Mama! . . . Mama! . . ."

A terrifying thought arose: perhaps I am losing my mind. I ought to see a psychiatrist. Yet while thinking this, I found myself saying:

"But who is calling me like this?"

"It's us, Mama."

"And who are you?"

"Your children, the ones you kept from being born."

I had neither strength nor time to scream.

"Look, we are here with you, all seven of us."

And I saw very clearly on the opposite wall between the mirror and the window seven spots of light, shapeless and moving about. They were moving, not sliding on the wall, but between me and the wall with an almost continuous change of appearance.

I was frozen. Once more the thought of being insane crossed my mind. I would have preferred a thousand times to be insane than to be convinced that this was real. "I would rather be crazy," I said to myself.

"No, Mama, all that you see is true. You are not insane. You are only guilty of having killed us in your womb."

I thought I was dying. I observed that while those spots of light were talking, they were very pretty faces, expressing such sadness and sternness as no mother will ever see in her children's countenances.

"We are not only shadows, we are real, Mama. If you wish, we'll prove it to you. A few minutes ago our very dear father died, but he is not with us."

They stared at me with an implacable gaze and then disappeared.

I don't know how long I remained breathless as though turned to stone, but a prey to indescribable fright.

* * *

I was aroused from it by the little bell of the Sisters of Perpetual Adoration ringing for the five o'clock Mass. I jumped from bed and got dressed as fast as I could. I don't even remember if I combed my hair. In a few minutes I found myself in one of the pews of the dimly lit and icy cold chapel along with five or six poor women.

From the subdued murmur in the side aisle, I noticed that the chaplain was in the confessional. As soon as it was free, without even thinking of what I was doing, I went to the confessional screen to tell him my experience of hearing and seeing.

"Just tell me, Father, whether ghosts exist and whether we can see them or hear them talking," I asked abruptly.

"There is no doubt, my daughter, that they do exist . . ."

"Did you say that they do exist?"

"As to seeing them, that is also possible, if for His mysterious ends the Lord allows it. But in this matter, one must be very sure that his imagination is not playing tricks."

"What kind of tricks?"

"Have you been attending seances?"

"Never."

"Then beware of your imagination; it is able to

do anything, even give body and voice to shadows. This is what I am afraid is happening to you. You are too nervous and too upset. The story you told me is so confused . . ."

"Then I am insane?"

"It is not my place to say; but I would advise you to see a good doctor. A psychiatrist would be advisable."

"Such as?"

He mentioned a well-known name.

"Meanwhile, why don't you go to Confession so as to receive the grace of God?"

"Now, Father, I just cannot . . ." I almost ran out of the confessional and out of the little church.

* * *

It was still dark outside. I was walking like a woman of the street. Some lonely pedestrians eyed me suspiciously. It was evident that I was tired and was walking aimlessly. At the corner a policeman, in a matter of fact way, asked me what I was looking for.

"Where can I find a restaurant, please?"

"Just a few doors to your right."

I followed his directions. The proprietor was just opening up.

"Espresso with cream."

"The espresso machine isn't ready yet; just

have a seat for a few minutes."

I sat in a corner which seemed to be sufficiently out of sight. It worked the other way and drew attention to me as soon as the customers began to come in.

"Women who work at night . . ." I heard the proprietor whisper to a tall, bald-headed man who seemed ready for some fun. I felt like slapping their faces. I could hardly wait for the tall man to leave. Instead, after drinking his coffee, he came straight to me with the evident intention of starting a conversation.

"May I sit here, Miss?"

"I would like you to know that I am a 'Mrs.' and would like to be left alone."

"May I help you in some way?"

"Yes, by going away and leaving me in peace."

"You must be very tired—perhaps from some great sorrow or too much work; one or the other."

To get rid of him, since he had malicious suspicions about me, I answered quickly: "I am in great distress: because of a false accusation my husband has been arrested and is in confinement."

At these words the man became perceptibly serious and sympathetic.

He took a seat across from me.

"When did this happen?"

"Eight or ten days ago."

"Could you tell me where they sent him?"

"What would be the use?"

"I might be able to help you: I have some good friends in the Party. What's your husband's name?"

I told him, but with open distrust.

"Why I know him! We worked together for about three years."

* * *

The details he gave me were quite accurate.

"Madam, I am very sorry that this has happened. I hope that I can do something for you. Perhaps I'll be able to let you know something even today. Give me your address. Would you rather I wrote to you, or may I come in person?"

"Whatever you prefer, as long as you can get me some information."

I gave him my address at once, and he left immediately.

* * *

That same evening, while I was examining some of my husband's papers, the door bell rang. It was the man I had met at the luncheonette that morning. He looked as if he had bad news.

"Well, tell me the bad news right away."

He was amazed: "How did you know? . . . Did they notify you already? . . . How come?"

"No one has told me anything, Sir," I replied,

inviting him to sit down.

"Then how did you know I had bad news?"

"A premonition."

"The word came just a little while ago. Did your husband have heart trouble?"

"Yes, slightly, for some years."

"He died of a heart attack, Madam."

"When, at what time?"

"Last night."

I must have fainted, stricken by that confirmation and even more by the dismay in realizing that those mysterious beings had made the announcement to me at the very moment that my husband was dying.

"I am afraid I'm losing my mind!" That is all I had the strength to cry out. I didn't see or know anything else after that.

When I recovered consciousness, I was undressed and in bed, my daughter was sleeping near me wrapped in a blanket and at my side was a Sister, who was a nurse. She had been called in that same night.

"How do you feel, Madam?"

My throat was constricted, so that I could not speak.

"Do you want a cordial? Try it; you will feel better."

She took my silence for assent. After swallowing it, I vomited violently.

"Tell me what the trouble is, Mother!" said my

daughter, who had awakened and thrown her arms around me.

I realized that she didn't know as yet about her father's death. With a sign I signalled silence from the others.

After the nausea had passed, I felt better. I looked at the clock; it was five in the morning.

"It was nothing, dear. Yesterday I was a little tired and I just had a fainting spell. Don't worry. I'll get up a little later; but I feel much better already. Now go and get some sleep in your own room. Don't say no. The Sister will stay with me."

As soon as she had gone and the door of her room was closed, I asked:

"Sister, how long have you been here?"

"I was called right after you had the spell. They told me what happened, so I advised them to say nothing to the young lady. In fact, I think you should tell her yourself—my poor dear."

"Thank you; thank you with all my heart! But what of the voices I thought I heard in my sleep? They were calling me."

"It was just a spell, Madam. Surely your daughter didn't call you, for she never stirred, once she fell asleep."

I could have sworn that I heard those voices calling clearly, and very close to me, as during the previous nights.

Later the Sister woke the housekeeper and asked if she could leave. "I don't think you

require my presence anymore. What you need is a great deal of strength from the Lord. I shall pray for you. It was, indeed, a cruel blow. I am sure that your husband is praying for you right now. They say he was such a good man. Have courage! Our Lord will not abandon you."

I listened as if in a stupor. When she said good-bye to me, I responded with a faint nod and a vacant stare.

* * *

About ten o'clock I had strength enough to get up. After a good cup of coffee, I even felt that I could go out, in spite of the remonstrances of my daughter and the housekeeper.

I told them that I had to go. I went to the convent nearby, and asked for the chaplain. I told him the whole story: the voices I had heard again, what I had seen, what they had said and how it proved to be true.

"And now, before going to the doctor, I am here to see you. Tell me, please, what I should think. How should I behave toward these phenomena? If I go straight to the doctor, you know, he'll think me insane and nothing will keep me from an asylum. At very least he'll think I have hallucinations."

"To tell you the truth, my daughter, I don't know what to think. It may be a warning from

God; it could be a phenomenon of telepathy."

"But has God ever permitted beings from the other side to appear and deliver a message to us on this side?"

"He has, my daughter. I think I already told you that. It is within the realm of possibility. But in your case, I would prefer the help of a physician. The name I gave you seems to be the one you need. Now, won't you make your peace with God through a good Confession? This is the time you should feel the need of it. Try above all to merit the dear Lord's help."

"They, too, told me that when they urged me to pray," I blurted out.

"And what does this show? What do we know about the ways of the Lord? Could He not be using all this to draw to Him a soul who is in need of His mercy?"

"Why should God care about the salvation of my soul after I took seven away from Him? Can you prove to me that I can be forgiven?"

This outburst of mine must have been a very strange and painful experience for the priest; but it proved to be Providential. While before he had seemed quite cold and almost without feeling and perhaps not too interested in my case, now his attitude changed. He found himself called upon to defend God's infinite and inexhaustible Mercy against one who never had had a true concept of it and who was on the brink of despair.

A sort of lengthy sermon followed to which I listened willingly and which did me good then and later on during certain periods full of sorrow when that horrible temptation reappeared.

He ended by saying something that I would have never believed before:

"Put on one scale of the balance all your past sins, and on the other this one sin of despair into which you are about to fall; God would be hurt more by this one sin, which strikes straight at His Heart, than by all the others."

Quite overcome by such touching and convincing language, I told him that I would be glad to make my Confession.

"But how can I tell such a sad story?"

"Nothing is easier if you have good will. I am here to help you."

It would not be enough to say that the Father got out of me all I had to say. He helped me to reveal even the most forgotten details regarding certain sins. I had the feeling that he was inspired from above. In placing myself in his hands, I felt a new and deep relief. Each revelation was like a load falling from my soul. At the end I felt that I was reborn—and I wept.

"Of course your past has been very sad, my poor daughter, but see how good the Lord has been to you. Instead of getting tired, He has been waiting for you with infinite patience. He wanted to make you an example of His mercy, and the strong feel-

ing you have of not deserving it is a proof that you have made a good Confession. I assure you with my priestly authority: God has forgiven you everything. Do not dwell on the past except to thank God and to love Him sincerely. Begin a new life today. It will probably be a life of expiation, but you will be sustained by Our Lord's grace."

At this time something that the Sister Portress at the Institute where I took my daughter had said came back to me: "They criticize Confession so much. But who are *they*? Those who do not know it. You'll never find anyone who frequents this Sacrament speaking ill of it or seeking excuses to stay away from it."

"And now, Father, what do you advise me to do? Should I go to the doctor or not?"

"Do as you think best."

"I'd rather have you tell me."

"Should these strange phenomena reappear, it would be better, or even necessary for you to go and see him. Otherwise, I don't see any need."

"So, may I feel safe about the past?"

"You must not worry. Realize that the first and best amendment you can offer to the Heart of Our Lord is to believe in His mercy and in the forgiveness He has granted you."

"But what about those poor souls?"

Here his voice again became stern and strong:

"Let bygones be bygones. Now obey God's minister. Go in peace and try to sin no more."

* * *

Never in all my life had I made such a Confession.

"The Lord has given you an immense grace," the chaplain had told me, "and to prepare you to receive it, I would not be surprised if He has allowed you in an exceptional way to hear the voices of your children who were killed before birth—but I might be wrong. Perhaps it isn't safe to pry into the mysteries of God."

As I knelt alone in the little Chapel of Adoration, I went through the words one by one, as they were spoken by that man of God. I found them so true and consoling. And I also remembered what he had said: "I told you that the Lord has forgiven you everything, but I did not say that He would spare you the expiation for your past. If this comes, remember that it is a sign of grace."

* * *

About a month passed without any special occurrence. The nuns' chaplain had become my confessor and my adviser in many matters. One day I asked him what I could offer to the Lord in exchange for those poor souls. "What you can do in substitution," he replied, "is to adopt many pagan children to be baptized with the names you

would have given to your own children."

I accepted this suggestion with enthusiasm. Thus I began to send each month to a missionary priest all the help I could to have some children baptized and supported in an orphanage.

I remember teaching this practice to my daughter, who also became the godmother of quite a group of children baptized with names chosen by her—and the majority were named after her father. Then when we received pictures of our distant godchildren, we gave them the place of honor on our living room walls and often had flowers in front of them.

*　　　*　　　*

After a period of relative calm and tranquillity, the vexation by the voices started again. I did not hear them in my sleep, nor in the state between sleeping and waking, but at different times when I was alone and was the only one to hear them.

"Mama, why did you kill us?"

What could I answer? Cringing, I remained silent and wept, while I felt those voices like a blade turning in an old wound.

One day I burst out: "Yes, my children, I recognize my guilt and ask your forgiveness." But although I repeated these words over again, there was no reply.

Once I asked instead: "Tell me if I can be saved."

"What do you mean by 'saved?'" I was asked.

What a strange question, I thought, and I did not dare to bring it up again.

As was to be expected, these repeated apparitions made me become so depressed that at the insistence of my confessor I had to see a psychiatrist.

A few days after his long, accurate and scrupulous visit, I was committed to a private sanitorium.

This was a sort of treachery on the part of the physician and of some of my close relatives. I can swear, however, that I never lost my mind for a moment. Today I am able to relate all that was said or done around me. Above all I remember how I was hurt by the words with which my daughter tried to comfort me; she believed that her mother was ill, and together with her fiancé, she had consented to keep me there.

I spent three years in tormented seclusion and martyrdom.

I remember that there was not one day that I did not think of the expiation foretold to me by the nuns' chaplain. He continued to give me his spiritual assistance in a very fatherly way. At times I was submissive, at times rebellious, but my habitual disposition was that of reparation.

Meanwhile I was still hearing the voices at intervals, and the reactions caused by that could not but confirm the opinion of the nurses and of

the doctors that my condition was doubtless a pathological one.

And yet I was certain that I was not insane, but that I was being subjected to an interior indescribable torture.

When I was calmer, I would pray without ceasing; yet this, too, was taken as one of the symptoms of my "mental illness."

* * *

One day—in fact it was between prayers—I was struck with an idea. I had heard of a holy priest whose prayers were said to be very powerful with God. I asked a Sister to bring me materials to write a letter. I obtained them with difficulty. I was just finishing my letter when my daughter and her fiancé came to see me. I gave him the letter. He kindly let me see him drop it in the mailbox at the hospital entrance which could be seen through the iron bars of my room.

I had to wait about twenty days. However, when the answer came, I don't know what it did to me or to the others; the fact is that shortly after, I was discharged.

"I am certain that the Lord, through the intercession of the Blessed Mother, will not fail to send you His grace, and that, soon," this man of God had written to me. When the incident became known in the hospital, he received any number of

letters from patients and their families.

Shortly after this my daughter married this young man who had just received his M.D. As a condition for their marriage I requested that the new family would live in my husband's house, for there was enough room to accommodate them and their presence would help to create for me an atmosphere more conducive to peace of mind.

However, my mental sufferings never ceased completely.

Without doubt my sincere repentance for what I had done, the grace of hope sustained by the Sacraments, the authority of my confessor—all helped to keep me from sinking into despair. Nonetheless I could never completely rid myself of the atrocious remorse for having interrupted seven pregnancies.

The doubt which caused me the most anguish concerned the destiny of these souls. There were times at which I was on the verge of losing my mind.

Once when this thought was particularly tormenting, I rushed out of the house as if a prey to madness. For a moment the idea of putting an end to my life by throwing myself under the first street car flashed through my mind. But without knowing how, I found myself in front of the little Chapel of Perpetual Adoration where I had gone to Confession. I went in.

The Blessed Sacrament was exposed high above

in a splendor of lights and flowers. It was very late
in the evening and there was no one in the pews.
Only two white-veiled nuns were kneeling in the
sanctuary.

I went to the far corner of the church, and there
my anguish overflowed in desperate tears. I don't
know how long I remained there. Then I gazed at
the monstrance and a question came to my lips:
"How can it be, my God . . . ! You showed me,
the guilty one, so much mercy—and aren't You
going to be merciful to those poor little ones? My
Lord, I can't believe it—and if that is blasphemy,
forgive me!"

As I uttered these words I felt a hand on my
shoulder. It was the chaplain—the priest I knew
and to whom I had so often confessed.

"What is it, child?"

"You know it all . . ." and I went on weeping.

"Do you want to tell me something?"—and he
pointed to the confessional.

I flew like an arrow and found myself kneeling
before the grate behind which he was sitting.
Instead of confessing I could only repeat what
obsessed me, the question I had just asked Our
Lord in the Blessed Sacrament. '

"Father, only tell me if I have blasphemed in
speaking to Him thus . . . !"

"No, my child, you have not."

"Then, Father, . . ."

"As a minister of God I can tell you this: Pray,

have trust in Our Lord and leave all to Him . . ."

"May I, then, hope . . .?"

"I told you: Pray, have trust in Our Lord and leave all to Him."

I could not help repeating: "Limbo . . . Eternity . . . You theologians . . ." I didn't know what I was saying, but he understood at once and interrupted me.

"My daughter, the theologians teach us what the Lord revealed about the ordinary ways of salvation. But he did not reveal to theologians what could be His extraordinary ways. That is why I told you, and I am repeating it to you for the last time: Pray, have trust in Our Lord and leave all to Him. I shall give you my blessing . . . And now, go in peace."

My heart began to flutter again and I was ready to faint. When the Father came out of the confessional I don't know what kept me from hugging him. It seemed to me that I would be embracing God Himself. He had never shown Himself so like a Father as in those words of His minister.

But this echo of divine mercy would make the sorrowful remembrance of my deeds even more painful.

And this, for the rest of my life!

If you have enjoyed this book, consider making your next selection from among the following . . .

Novena of Holy Communions. *Lovasik* 2.00
The Forgotten Secret of Fatima 1.50
Characters of the Inquisition. *Walsh*. 15.00
Teilhardism and the New Religion. *Smith* 13.00
The Facts about Luther. *O'Hare*. 16.50
Pope St. Pius X. *F. A. Forbes*. 8.00
St. Alphonsus Liguori. *Miller & Aubin* 16.50
St. Teresa of Avila. *Walsh* . 21.50
Therese Neumann—Mystic and Stigmatist. *Vogl* 13.00
Life of the Blessed Virgin Mary. *Emmerich* 16.50
The Way of Divine Love. (pocket, unabr.) *Sr. Menendez.* 8.50
Light and Peace. *Quadrupani*. 7.00
Where We Got the Bible. *Graham* 6.00
St. Catherine of Siena. *Curtayne* 13.50
Trustful Surrender to Divine Providence. 5.00
Charity for the Suffering Souls. *Nageleisen* 16.50
The Voice of the Saints. (Sayings of) 6.00
Catholic Apologetics. *Laux* 10.00
St. Rose of Lima. *Sr. Alphonsus*. 15.00
The Devil—Does He Exist? *Delaporte* 6.00
A Catechism of Modernism. *Lemius* 5.00
St. Bernadette Soubirous. *Trochu*. 18.50
The Love of Mary. *Roberto* 8.00
A Prayerbook of Favorite Litanies. *Hebert*. 10.00
The 12 Steps to Holiness and Salvation. *Liguori* 7.50
The Rosary and the Crisis of Faith 2.00
Child's Bible History. *Knecht* 4.00
St. Pius V. *Anderson* . 5.00
St. Joan of Arc. *Beevers*. 9.00
Eucharistic Miracles. *Cruz*. 15.00
The Blessed Virgin Mary. *St. Alphonsus* 4.50
Priest, the Man of God. *Cafasso* 12.50
Soul of the Apostolate. *Chautard*. 10.00
Little Catechism of the Curé of Ars. *St. J. Vianney.* 6.00
The Four Last Things. *von Cochem* 7.00
The Cure of Ars. *O'Brien* . 5.50
The Angels. *Parente* . 9.00

Prices subject to change.

Moments Divine—Before Bl. Sacr. *Reuter* 8.50
Raised from the Dead—400 Resurrec. Miracles 16.50
Wonder of Guadalupe. *Johnston* 7.50
St. Gertrude the Great. 1.50
Mystical City of God. (abr.) *Agreda*. 18.50
Abortion: Yes or No? *Grady, M.D.*. 2.00
Who Is Padre Pio? *Radio Replies Press* 2.00
What Will Hell Be Like? *St. Alphonsus*75
Life and Glories of St. Joseph. *Thompson* 15.00
Autobiography of St. Margaret Mary 5.00
The Church Teaches. *Documents* 16.50
The Curé D'Ars. *Abbé Francis Trochu*. 21.50
What Catholics Believe. *Lovasik* 5.00
Clean Love in Courtship. *Lovasik* 2.50
History of Antichrist. *Huchede*. 4.00
Self-Abandonment to Div. Prov. *de Caussade* 18.00
Canons & Decrees of the Council of Trent 15.00
Love, Peace and Joy. *St. Gertrude/Prévot* 7.00
St. Joseph Cafasso—Priest of Gallows. *St. J. Bosco*. . . . 4.50
Mother of God and Her Glorious Feasts. *O'Laverty*. . . . 10.00
Apologetics. *Glenn* . 10.00
Isabella of Spain. *William Thomas Walsh*. 20.00
Philip II. H.B. *William Thomas Walsh* 37.50
Fundamentals of Catholic Dogma. *Ott*. 21.00
Holy Eucharist. *St. Alphonsus* 10.00
Hidden Treasure—Holy Mass. *St. Leonard* 5.00
St. Philomena. *Mohr* . 8.00
St. Philip Neri. *Matthews*. 5.50
Martyrs of the Coliseum. *O'Reilly* 18.50
Thirty Favorite Novenas .75
Devotion to Infant Jesus of Prague75
On Freemasonry (*Humanum Genus*). *Leo XIII* 1.50
Thoughts of the Curé D'Ars. *St. John Vianney* 2.00
Way of the Cross. *St. Alphonsus Liguori* 1.00
Way of the Cross. *Franciscan* 1.00
Magnificent Prayers. *St. Bridget of Sweden* 2.00
Conversation with Christ. *Rohrbach* 10.00
Douay-Rheims New Testament. 15.00
Life of Christ. 4 vols. H.B. *Emmerich* 60.00
The Ways of Mental Prayer. *Lehodey*. 14.00

Prices subject to change.

Miraculous Images of Our Lord. *Cruz*	13.50
Ven. Jacinta Marto of Fatima. *Cirrincione*	2.00
Ven. Francisco Marto of Fatima. *Cirrincione*, comp.	1.50
Spiritual Conferences. *Tauler*	13.00
Is It a Saint's Name? *Dunne*	1.50
Prophets and Our Times. *Culleton*	13.50
Purgatory and Heaven. *Arendzen*	5.00
Rosary in Action. *Johnson*	9.00
Sacred Heart and the Priesthood. *de la Touche*	9.00
Story of the Church. *Johnson et al.*	16.50
Old World and America. *Furlong*	18.00
Summa of the Christian Life. 3 Vols. *Granada*	36.00
Latin Grammar. *Scanlon & Scanlon*	16.50
Second Latin. *Scanlon & Scanlon*	12.00
Convert's Catechism of Cath. Doct. *Geiermann*	3.00
Christ Denied. *Wickens*	2.50
Agony of Jesus. *Padre Pio*	1.50
Tour of the Summa. *Glenn*	18.00
Three Ways of the Spir. Life. *Garrigou-Lagrange*	6.00
The Sinner's Guide. *Ven. Louis of Granada*	12.00
Radio Replies. 3 Vols. *Rumble & Carty*	36.00
Rhine Flows into the Tiber. *Wiltgen*	15.00
Sermons on Prayer. *St. Francis de Sales*	4.00
Sermons for Advent. *St. Francis de Sales*	7.00
Sermons for Lent. *St. Francis de Sales*	12.00
St. Dominic's Family. (300 lives). *Dorcy*	24.00
Life of Anne Catherine Emmerich. 2 Vols.	37.50
Manual of Practical Devotion to St. Joseph.	15.00
Mary, Mother of the Church. *Documents*	4.00
The Precious Blood. *Faber*	13.50
Evolution Hoax Exposed. *Field*	6.00
Devotion to the Sacred Heart. *Verheylezoon*	15.00
Chats with Converts. *Forrest*	10.00
Passion of Jesus/Its Hidden Meaning. *Groenings*	15.00
Baltimore Catechism No. 3.	8.00
Explanation of the Balt. Catechism. *Kinkead*	16.50
Spiritual Legacy of Sister Mary of the Trinity.	10.00
Dogmatic Theology for the Laity. *Premm*	20.00
How Christ Said the First Mass. *Meagher*	18.50
Victories of the Martyrs. *St. Alphonsus*	10.00

Prices subject to change.

Sermons of the Curé of Ars. *Vianney* 12.50
Revelations of St. Bridget of Sweden. *St. Bridget* 3.00
St. Catherine Labouré of the Miraculous Medal 13.50
The Glories of Mary. *St. Alphonsus* 10.00
St. Therese, The Little Flower. *Beevers* 6.00
Purgatory Explained. (pocket, unabr.) *Fr. Schouppe* 9.00
Prophecy for Today. *Edward Connor* 5.50
What Will Hell Be Like? *St. Alphonsus Liguori*75
Saint Michael and the Angels. *Approved Sources* 7.00
Modern Saints—Their Lives & Faces. Book I. *Ball* 18.00
Our Lady of Fatima's Peace Plan from Heaven.75
Divine Favors Granted to St. Joseph. *Pere Binet* 5.00
Catechism of the Council of Trent. *McHugh/Callan* . . . 24.00
Padre Pio—The Stigmatist. *Fr. Charles Carty* 15.00
Fatima—The Great Sign. *Francis Johnston* 8.00
The Incorruptibles. *Joan Carroll Cruz* 13.50
St. Anthony—The Wonder Worker of Padua. 5.00
The Holy Shroud & Four Visions. *Fr. O'Connell* 2.00
St. Martin de Porres. *Giuliana Cavallini* 12.50
The Secret of the Rosary. *St. Louis De Montfort* 3.00
Confession of a Roman Catholic. *Paul Whitcomb* 1.50
The Catholic Church Has the Answer. *Whitcomb* 1.50
True Devotion to Mary. *St. Louis De Montfort* 8.00
I Wait for You. *Sr. Josefa Menendez*75
Words of Love. *Menendez, Betrone, etc.* 6.00
Little Lives of the Great Saints. *Murray*. 18.00
Prayer—The Key to Salvation. *Fr. M. Müller.* 7.50
Sermons on Our Lady. *St. Francis de Sales* 10.00
Sermons of St. Alphonsus Liguori for Every Sun. 16.50
Alexandrina—The Agony and the Glory. 6.00
Life of Blessed Margaret of Castello. *Fr. W. Bonniwell* . 7.50
St. Francis of Paola. *Simi and Segreti.* 8.00
Bible History of the Old and New Tests. *Schuster* 10.00
Dialogue of St. Catherine of Siena 10.00
Dolorous Passion of Our Lord. *Emmerich* 16.50
Textual Concordance of the Holy Scriptures. 35.00
Douay-Rheims Bible. *Leatherbound.* 35.00

—At your Bookdealer or direct from the Publisher.—
Call Toll-Free 1-800-437-5876.

Prices subject to change.